COMPLETE
THE
STORY

Some

stories end

badly, some

end well,

and others

just keep

going on...

At first, we thought the black liquid was oil, that we'd struck it rich and that we'd be able to retire and live in leisure. We actually started writing down all the ways we'd spend the money. Our first choice was

Perhaps it was a dream, she thought. Perhaps if she pinched herself, she would wake up. But she didn't want to wake up. She wanted to stay in this dream world where _____

I've lived in this town my whole life, and most of the time that's fine by me. But in late fall when the sky fills with birds migrating south for the winter, traveling thousands of miles, I get homesick for places I've never been. Places like _____

"How did you know?" I asked, not sure I wanted the answer. I thought I had been careful. I thought she

The wind whispered through the dark, empty trees like a warning in a foreign language. Winter was coming, and with winter

Reporters are trained to develop a sixth sense, a nose for when a story smells fishy. And something about this one wasn't right. First of all, _____

The yellow lines on the highway sped by in a blur, and we flew through the night, and we felt free. But we weren't, and we knew it. We were running away from something, and running away was never the path to freedom. I thought about telling John to turn back. I thought about suggesting

Looking back, it could have gone either way. It didn't work out, which makes it look like fate, or a stupid decision, or both. But at the time, I did have a few things in my favor. I had

It flashed through the sky and then was gone. Lucy was sure she had seen a UFO and was equally sure aliens were here to secretly make contact with a human being. Maybe they would choose her. Maybe she would get to visit their ship. Maybe

The darkness was thick and suffocating, like a heavy blanket had been thrown on the world. He had to get over the wall, had to get across the border before _____

Until that day, fear had been an idea, a concept. Now it was real: a feeling I would carry inside me for the rest of my life. The day began innocently enough, with _____

The music drifted out of the club like a vibrating pulse. I could feel it in my bones. The night was alive with possibility. I could even imagine myself

She believed in me in a way no one else ever had and no one else ever will, and I betrayed her. The worst part is she doesn't know. She still thinks

It began as a practical joke. But by the end of the day, nobody was laughing. It seemed innocent enough at first, because Jerry and I have a history of playing practical jokes on one another. He was the one to start the whole thing, if I'm not mistaken. He _____

Harry shuffled the deck of cards and pushed it across the table. "Deal," he said. "One more hand," I agreed. It was a way to pass the time. More importantly, it was a way to avoid talking about

The soldiers were tense, waiting for something to happen—like it was a matter of when, not if. For our part, we did our best to steer clear of them, avoiding the main square, where a group of protestors

He sprinted away, not daring to look back, his footsteps echoing down the hallway like distant gunshots. He just had to get to the back stairway and up to his office on the second floor, where

We took turns guarding the door, neither of us sleeping very much. Ricky looked nervous, and suddenly I felt bad about getting him involved. I shouldn't have

The desert is an unforgiving place. This one is called Death Valley for a reason. Every living thing there has to fight for survival. And we would have to fight, too, or else

I asked her if she was joking. Her frown told me she wasn't. "Every last penny, gone," she said. "And that's not the worst of it," she continued, leaning across the table

The lake was as still and shiny as glass, as if he could step on it and walk all the way across. It was one of those days when anything seems possible, and he stood there, breathing deep and imagining

"Deal?" he said, extending his hand toward me. I hesitated then reached out. Frank thought he had the upper hand, and in a sense he did. What he didn't know was that

Even after a long day at work, my mother's hands worked tirelessly: chopping vegetables for dinner, stitching our clothes, whatever needed doing. I loved her hands and admired them. I wanted to be strong like her. But at the time, I couldn't be. I would have, and gladly, if I weren't so

Sometimes kids are the only ones willing to say what's really on their minds, and our family needed a little dose of honesty. We almost never said something straight out. My mother was the worst. All she would do was _____

I stopped for a breath before cutting the turkey. I wanted to appreciate the moment. Seeing everyone there, sitting around the table, almost felt like we were a family again. But if we had been a real family

I didn't cry when she died, or at the funeral, or at the reception. It wasn't until the next morning when I went into the pantry and saw row upon row of canned vegetables, fruits and jams she had prepared for the long winter ahead. The shelves were filled with _____

To call him stubborn would be polite. Not that politeness mattered to him. Malcolm would probably describe himself as principled. Those closest to him would probably use different words, like

It was different, writing on a typewriter: the clatter and noise, the resistance of the old keys forcing her to really put some effort into each letter. She imagined she was

It was odd to be in a room full of people who all seemed to look up to my dad like he was some kind of hero. A part of me wanted to see him through their eyes just for a moment. I tried to picture him as

After the funeral, I spent the next few days in the attic, reading the letters my mother had written him in the years before they were married. He had never been the sentimental type, so I was surprised to find a whole box of them, carefully bundled. Even more surprising was

It felt uncanny, but oddly good, to hear kids running through the house again. I wondered if I could handle being a father, or at least a father figure, after all these years. I thought about the times when

Always the same old lines whenever she came home for the holidays, like her parents were rehearsing a play over and over and never could get it right. Yet they didn't seem to notice how much they repeated themselves. Her father would sit down to dinner and say

She kept pacing the living room, back and forth, back and forth, not saying a word. It would have been easier if she had just come out and told us how disappointed she was, announced our punishment, and sent us to our rooms. But she wanted us to apologize, or explain, or something. Finally, I couldn't stand the silence any longer and I

She was the new girl. The one who sat in the cafeteria at lunch alone. Maybe she was from the next state over. Maybe she was from another country. I wanted to know everything about her: her mother's name, her favorite movie, if she had brothers, sisters, what she

In German it's called a *doppelganger*, a look-alike. Literally, a "double-goer." I stared at the boy in the newspaper article. Was it possible that he _____

As a kid I'd spend almost all of my allowance money on going to the movies. I'd go see a double feature on a Saturday afternoon and emerge from the dark theater into the blinding sunlight, and it seemed like it was the "real" world that was made up and fake. So I'd walk home and invent stories about the people in town, like Mr. Roberts, our mailman, who

I sat down next to her on the couch. It was time to start telling the truth. But I couldn't just dive into the heart of the matter, so I started with the little things. I told her

He wasn't sure how he was able to do the math problems in his head like that. He just closed his eyes and the numbers found their places, like trained dancers, or like _____

I said it and I meant it, and I was right. Still, I wish I could take it back, because there's no way I can make it up to her, no way I can ever make her feel

He had hunted and hiked and led backpacking trips through these woods for twenty years, and he had never seen an animal track like that. At first glance, it resembled _____

He was trying to remember that quote from Scripture, about the camel passing through the eye of a needle—or was it a rich man, or a rich man riding a camel? Justin loved going to church and hearing the minister read from the Bible, but when he tried to read it on his own, he got confused. Like that other passage, the one about

It was just a game, of course. But it was more than that, and everyone knew it. They were from the upscale part of town, and we were from the wrong side of the tracks. Literally. North of the rail line

It was like an echo from the past, or a dream that he was only just now remembering. He recognized everything about the room, even though he was sure he'd never been there before. He knew the paintings on the walls, could name the artists who'd painted them. The only thing that puzzled him was

"Clarissa," she said, correcting her teacher. Names were important. For years, she'd been embarrassed about her name and wished it were something ordinary. But then something happened that changed her mind. That day _____

When he tried to express himself with words, he could never get it right. But with his hands, he could shape things, mold things, and make things. He had discovered that gift as a young boy when he

After my father's stroke, he started crying all the time. He cried about everything: sentimental commercials, pop songs on the radio, or

The moon broke through the clouds, and the four of them stood there, frozen, waiting for something to happen. They were in the middle of an open field, and it was as if a spotlight had been trained on them. Suddenly, without warning

The day was scorching hot and bone dry, the air smelled like burnt toast, and everyone's nerves were on edge. Only Zeke was calm. He patrolled the perimeter, making jokes about _____

I told Eddie it didn't hurt too badly. "Give it a couple of minutes," he said, smiling that smile of his. Like he knows it's going to hurt, and like he's secretly going to enjoy it. Eddie has this habit of being by my side when times are tough. He was there when

When Bobby tells a joke, you're always wondering if he's going to take it just a little bit too far. He's got this image of himself as outrageous and controversial, when in reality he _____

All right, maybe it wasn't the best way to start off a conversation. In my own way, I was trying to take her side. It's not easy to take her side, and very few people do. She has two, maybe three real friends in the world. There's me, there's

You know when even the things you dislike about a person make you love her even more? Well, that was Mary. On the one hand, she

Don't let this one get away, she thought to herself. Tom had the look of a man quietly planning his escape. Christine watched him closely as he

They were getting married in just three weeks, and things were not looking good. They hadn't found a decent band, and Sheri was not going to have a DJ at her wedding. While Daryl didn't have an opinion about anything, his mother seemed to have an opinion about everything, even the

She told him to try again, and he did, and she couldn't help but laugh. "I told you I wasn't a dancer," he said, protesting. "But you're an athlete," she said, "you _____

They've done all these studies about how twins remain connected, psychically, their whole lives. I haven't seen Sally for twenty years, but sometimes I wake up in the middle of the night with pain in my knee and I know it's her pain, not mine. Or I'll be taking a walk and I'll feel

The boy woke up before dawn. The horses were restless. Something wasn't right. He rose and tiptoed quietly down the hall, careful not to wake his mother. She was exhausted after last night's

As a young girl, she learned how to juggle fruit: apples, oranges, sometimes pears. There was little risk, little drama, and people smiled politely and then moved on. But they started paying attention when she started juggling

The doctors had never seen anything like it. She was a perfectly healthy little girl who just happened to have two hearts. The only explanation they could offer was

It was just ridiculous enough to be true. Then again, she could be making the whole thing up. It was just so hard to imagine Diane's father, the respectable banker who never left the house without a suit and tie, actually

"They're out there," he told me. "Fields and fields of them. As far as the eye can see." I wasn't sure what he was talking about. He pointed to the horizon, and I looked, but all I could see was

He had trouble walking, trouble standing up, trouble buttering his toast. But his mind was as sharp as ever. He had this amazing way with trivia. He could tell you

I know most people find the beach relaxing. But when I'm standing there on the shore at high tide, watching the effect the moon has on the great oceans of the world, I find myself wondering what effect it has on my insides, which are more than half water themselves, and I get dizzy. I'm like that, I think too much about things, like _____

It had been more than two weeks since the fire, but the stink of it was still in her hair, on her skin. She took long showers twice a day, but the smell lingered. When she closed her eyes at night, the images came back to her, images of

A group of young men strolled down the street as if they were training to be secret agents. It was the kind of town most young people dreamed of escaping, where everyone had their own private fantasy. Some might have ideas about

I wanted to believe him. I really did. But I had trusted him before, and it hadn't worked out that well. So now when he assured me that

'm not making excuses. But I have my reasons, and there's a difference. What else was I supposed to

.o when

As a servant, Tammy was used to saying "Yes, Ma'am," and "Of course, Miss." So she was as surprised as anyone else when she

Sally was a half hour late, which I guess was a half hour early by her standards. She operated on her own clock, lived in her own world. Which explains how

They didn't have to like her as long as they never forgot her. She had read studies about that: how people can deal with being disliked, but they can't deal with being ignored. And for far too long, Tara had been ignored. The only thing people noticed about her was

My options were dwindling by the minute. Right or wrong, I had to do something I couldn't just wait this one out. I told my secretary to cancel all my appointments for the afternoon and slipped out the back door and into the alley. And sure enough, waiting for me there was

There were so many languages flowing through her house when she was growing up—Russian, Ukrainian, Hebrew—it was like a rich farmland fed by many rivers. Each had its own rhythm, its own music. Russian made her imagine

Galileo was put on trial and spent the last years of his life in prison for suggesting that the earth revolved around the sun. We think we have a pretty good idea of how the universe works now, but what if we don't? What if we're wrong? What if

It was strange to sit up in bed and smell the coffee coming from the kitchen and realize I wasn't the first person up. I liked the idea of a hot cup of coffee waiting for me downstairs. But for so long it had been my kitchen and my kitchen alone, and I

Who did I think I was fooling? I wasn't fooling myself, that was for sure. But maybe I could stay one step ahead of them, at least for a while. It would give me time to

Secretly, he had always thought of Coach as his second father. His real father was pleased with everything he did, and in a way it was too easy. Coach was never satisfied, and somehow that felt more honest, better able to

I didn't expect to see her, not on this night, not at this party. She normally went out of her way to avoid parties. When we first met

Samantha dove off the board and cut through the water almost silently, like a knife. She thought of herself that way: as a knife, small, quiet, and strong. Her brother William may get all the attention, but she

"All right, that settles it," she said. I had my doubts, but I wasn't going to say anything, not just yet. You've got to pick your moments, and you've also got to pick your battles. I wanted Suzy to feel like she owed me one. I'd need her on my side when

I know this sounds weird, but I actually like going to the dentist. When they're scraping at my teeth, poking at my gums, I somehow feel vividly alive in a way I normally don't. I can almost forget the fact that

"When did you fall in love with him?" Anne asked her mother. She wanted to know. She needed to know. Especially on this day, when

For a few years, the three of them were inseparable. Then came high school. And teenage romance. And who got the girls, and who didn't. Andy definitely did, Lenny definitely didn't, and Mark was somewhere in between, which made him feel like it was his job to hold the group together. He tried to

When I hear the phrase "crazy like a fox" I think of Brad Munroe. He'd say or do things that didn't make sense, and you'd wonder what he was up to. But he was always up to something. There was always an angle, a scheme, like that time he

We had worked that farm as a family for three generations. The daily routine of farm life was in our DNA. We got up before dawn and started the day out on the

On the morning of her sixteenth birthday, Claudia decided to stop smiling so much. She wanted people to take her more seriously. If she felt the urge to smile, she would

His spelling and handwriting were atrocious. His test scores were so low it seemed he was going out of his way to get the answers wrong. But somehow she knew this kid was different. He had this way of knowing _____

The stranger moved in next door almost without us noticing. He seemed to have brought no luggage, no furniture, no boxes, nothing. Nothing but the dark suit that was all he wore as far as we could tell. We never even heard him utter a word until the day

She was always up at the window, waiting, even before the car pulls into the driveway. I know she just wants to see her father. But what she doesn't realize is

He closed the door shut and leaned back against it as if it wouldn't stay shut without the weight of his body. He felt like he had half the world chasing after him. An exaggeration, yes, but when you started adding up people like

I watched the hawk high in the sky float, and float, and float. Then it tucked its head in and dove like a missile, straight toward

Let me give you a list, a top ten list of things NOT to do when you're breaking up with a girl. At Number 10

It was strange to see two moons in the sky at night. To me, it was beautiful, and a kind of comfort, like someone was watching out for us. But other people reacted differently. Some believed

At first, skipping a grade seemed like a reward, an honor. A part of her thought she might even be presented with a certificate of some sort. But when she walked into the classroom, she realized

It couldn't take much longer, he thought. A day or two at most. He sat down at his big maple desk and wrote down two lists, one for himself, one

I closed my eyes. The sound of people clinking glasses was beautiful, almost like wind chimes. Why, then, did I feel so unbearably sad? When I opened my eyes and looked around the table I saw

She has this gentle laugh that sounds like running water. I'll do almost anything to amuse or entertain her, just so I can hear it. But she's not laughing all that much anymore, is she? Ever since

looked up at the night sky and thought of the stories he used to tell about the stars, the constellations, and it seemed sad that I couldn't remember a single one of them. There's a string of stars called Orion's Belt, and I think Orion is known as a hunter, but I'm not sure of what. It's funny to think that, because in a way I'm a hunter, too, only I hunt

They were safe, for the time being. But it was no time to let their guard down. Slowly, Samuel opened the car door, trying his best not to make a sound. He looked both ways down the street. All he could see was

I like helping Pop in the bakery. He says cooking is an art, but baking is a science. On one really hot day, he put ice into the big bread mixer so the dough would come out warm but not too warm. He used a formula to figure that out, and he has other formulas, too, things like _____

Finally, she had no choice but to call the sheriff's office. Stanley said it would only makes things worse, but she didn't see how that was possible. What could be worse than _____

He had this way of making you forget your troubles—as if the day was a blank page, wide open, and anything was possible. It was a marvel, because he'd had such a difficult life himself. As a child

The waves rise and fall and crash in a gentle rhythm, and I can almost forget. I get to the lighthouse, turn around, and my footsteps are already gone. I like that. But there are certain things you can't erase

Her husband used to be famous. Being married to the man who for a few weeks was on the front page of every newspaper, and who then suddenly disappeared, made her famous, too, at least in this town. There were rumors, of course, about

I know it didn't really happen this way, but at this point it almost doesn't matter. There's a picture in my mind of the real story, the true story. And as far as I'm concerned, it started the day

After three days, the storm let up and the winds died down. But there were dark clouds on the horizon, and we knew we didn't have long. They'd be out looking for us, so we had to load up on supplies, hit the road toward

I couldn't let them get away with it. They, and people just like them, had gotten away with similar things in the past, like

"I'm a lousy liar," he told me the first time I met him. He had a habit, I would soon find out, of speaking in riddles. At the end of that same encounter he also told me about the time he

Only another mile, I thought, keeping my head down. I watched each foot rise and fall, rise and fall, losing myself in the rhythm of it. I thought of what was on the other side of the mountain, and I remembered

I wasn't expecting it, but I wasn't exactly surprised either. Maybe I'd seen it coming. At the very least I should have seen it coming. There had been signs, of course. I should have noticed

We stayed up all night, sitting around the campfire, each trying to top the other with an even scarier story. We started with the basics: stories about

I knocked on the door again. No one answered, but I knew the house wasn't empty. They were expecting me to give up and go away, but I had other plans. I climbed the

"Tell me the whole story," he said calmly. "Take your time." That was easy for him to say. From where I sat, it looked like I was running out of time. Just yesterday

After the storm passed, we headed outside with brooms and dustpans to help sweep up broken glass. We'd only been in town for a week and didn't really know anyone. The little café on the corner had been hit hard, and the sidewalk outside was littered with

Yes, he was one of us. But we weren't going to take the fall for him, not this time. He'd gotten us in trouble before, when

He said he could mathematically prove that the Pyramids were built by aliens. He had other wild theories, too, like

He had to admit it: she was a natural. He was happy for her, but also a little jealous. And he felt bad about being jealous because she had always supported him, even when

Every muscle in his body hurts. Every tendon feels stretched to its limit. It's as if his body is telling him to stop, to lie down, to give in, give up. But he can't. If he doesn't get there in time

There's this scene in *The Godfather* where Marlon Brando leans over and tells his son, "Keep your friends close, and your enemies closer." For a long time I couldn't figure out what he meant by that. Now I realize

Even as a young girl, my little sister had always seemed older and wiser, as if she had glimpsed the future and was going to keep it all to herself. She knew things you just wouldn't expect a small town girl to know, like

Her thick glasses, her old-fashioned clothes, and her unidentifiable accent all gave off the impression she was from another place, another time. And maybe she was. Maybe she was a time traveler, a visitor from

It quickly became a game: who was going to say the first word, who was going to smile, who was going to pretend to cough, and who was going to make the first move. Jack stared straight at his coffee, stirring and stirring it even though he drank it black. Sammy

As a boy his eyes were round and the clearest blue, like a sky with no clouds. He had hope running through his veins. I remember how he used to

It was a very strange idea for a Halloween costume. But let's be honest, my nephew is a very strange little boy. For instance, in his world it's perfectly normal to _____

I was trying my best not to lose my temper. But sometimes it seems like Charlie's main goal in life is to make me angry, to make me lose my cool. He's been doing this for years, starting with the time

"She could start an argument in an empty house," goes one Southern expression, and that about describes Aunt Millie to a tee. Once, she even _____

I'd called everybody I could think of and I was still ten grand short. That is, everybody but the one person I really didn't want to ask, the one person who

At the other end of the lake, far away from the restaurants and the country clubs and the golf courses, is a run-down little cabin that you might miss if you weren't looking for it. And not many people are looking for it. Usually, the only people who make it to this side of the lake are

I don't speak Spanish, but it felt like I could understand exactly what he was saying. He didn't mean to bother me, and he wasn't begging, but could I please take a minute to look at the things he had made? So I stopped, took off my sunglasses, and looked at the table he'd set up on two milk cartons. On the table were

It was too quiet, too peaceful to be true. He should have known better. But he was hoping it was over, hoping to return to his everyday routine, but instead

At the time it seemed like a strange thing to say. Maybe it was her way of warning me. Edith had that air of mystery about her, like she was speaking in code and it was my job to decipher the code. She had spent time in dangerous parts of the world, of course, places like _____

People give me credit for seeing what was coming, but I think it was more luck than anything else. I couldn't sleep, and I felt like going out for a drive. That's the truth. And it seemed like a normal, quiet night until

He dropped to one knee and began snapping photographs. He didn't want to miss anything. Most everyone was running away from the explosion, but others were

It's hard to imagine a date getting off to a worse start. And believe me, I know about dates and bad ways to start them. You could almost say I've become an expert on the subject. On my first bad date

Her mother dipped a finger into the sauce, tasted it, and frowned. Elise had always wanted so badly to please her, to just once get something right the first time, that she was desperate. That's why this time she _____ .

So typical of Eileen—so very, very typical. She's done this before. Maybe not exactly, but close enough. Like the time she

In Fairbanks, Alaska, for a few days each summer, the sun doesn't set until after midnight. It's called the midnight sun, and the locals had warned me it would mess with my head. Maybe that's why last night had turned out that way. All I wanted was to

She said her favorite color was black, and I tried to tell her that black isn't a color, that black is in fact the absence of color. I tried to explain that, in physics, every color has its own wavelength, and neither black nor white has a specific wavelength. She stared at me for a moment, and then she said

Our Uncle Matt was larger than life. When he visited he gave each of us a silver dollar, which he told us he got from robbing a bank. He told big stories like that, and we didn't care if they were true. There was the story about _____

We were finally going to meet Jesse's parents, and everyone was nervous, no one more so than Jesse. I could tell just how nervous he was when

"Do you believe in ghosts?" he asked her. He made it sound like a statement, not a question. She stayed quiet, hoping he'd continue on his own, and after a few moments, he said

I hadn't seen Carrie since high school. She seemed the type who'd get married early and settle down, maybe skip college. The last place I expected to run into her was in a grad school library, a stack of books on either side of her with titles like

He spread the map out on the table. "Here," he said, pointing to a town I'd never heard of, in a state I'd never visited. The closest I'd been was Oregon, and I'd only been there once, twenty years ago, when

Even though I know I wiped down the tables the previous night, I wipe them down again in the morning before opening up. It's my favorite part of the day. I have my reasons, you see, for wanting each day to be its own clean slate

Tommy kept walking, trying not to let his limp show. It made his leg hurt even more, but it was important not to stand out. Not in this neighborhood, and not on a day when

Kelsey had a problem, and that problem had a name. She wrote it down slowly and stared at it. Even on paper, his name looked like trouble, starting with the letter _____

The police thought it was a simple burglary, but Ethan knew better. They'd taken some jewelry but had left behind an expensive watch. There were other things that didn't make sense either, like the way

For the first time in years, it was going to snow on Christmas. Maybe it was a sign that we could start over, that the coming year would be as clean and fresh as newly fallen snow, erasing from our memories the _____

"How could you?" she asked, hands high in the air—and at first I had no answer. There was no excuse for what I had done, and I wasn't about to make one up. But the one thing she didn't understand, the one thing I needed her to understand,

They say the third time's a charm. What about the fourth, or the fifth? Do your odds suddenly start going down? Odds are important in my line of work, you see, because

"Don't be nervous," she told me, sounding, well, nervous. I had other reasons to be worried that day,

"Who, me?" I asked, doing my best to sound innocent. My job at this point was to keep Marty guessing, to buy some time for

It could have been a disaster instead of a new beginning. In a way it was a little bit of both. And with all the things that happened this past year, we were all in need of a new beginning. We deserved it after

At times like these, I didn't know whether to laugh or to cry. So I tell the group a joke, a bad joke, the one about

"It's just a phase, you'll grow out of it," my father said to me at the time. I've spent the rest of my life trying to prove him wrong, trying to show him I could

The buzzer rang, and she ran to the door sure it was Steven, but it wasn't. It was an older man with a serious look on his face, not even a hint of a smile. He wore a long, dark raincoat even though it was a warm summer night. He introduced himself as

Love comes in all shapes and sizes. And sometimes it's disguised as something else. It's natural for me to think about disguises because

"Are you serious?" I asked her, somehow hoping against hope that she wasn't. She was quite serious. She was getting in the car and driving to California, with or without me. She had just gotten off the phone with

The name Abigail means "father's joy," which is ironic, because her father had wanted a son and didn't hide the fact. He let her know in countless ways how disappointed he was about having a daughter. Ever since she was a little girl, he

Are you staying, or are you going? And if you're going, how do I make you stay? Would it make a difference if I

Even before I said it, I regretted it, but I knew I had to say it anyway. And Ted needed to hear it, too. He needed to understand why I

Parades are supposed to be celebrations. This felt different. Maybe it was the dark clouds, or the slight mist in the air, that made the whole thing feel like _____

I couldn't tell if she was truly confident—or just really good at faking it. And I know a thing or two about faking it. "Fake it till you make it," my old man used to say. Of course, he also said

n twenty years, no one will talk about today, as if it never happened, and that's a shame. People should talk about it, people should remember

It was her first starring role. She should be happy. So why did she have this hollow feeling in the pit of her stomach? Was it just nerves, or did it have something to do with

Things would never be the same—that much was clear. How had things changed so quickly? I thought back to the day we moved in, not even a year ago. Back then

The leaky faucet in the kitchen was dripping as if someone was tapping out a lonely beat on a drum, like a broken clock struggling to keep time. It felt like the world was slowly unraveling and coming apart. I thought back to that morning, when

The drumsticks felt like extensions of his body—as if he was naked or incomplete without them. He took them to school even when there wasn't band practice. When he had a spare minute he'd take them out and practice riffs and rudiments on his notebooks, on the sidewalk, even

I wouldn't have recognized him. It was my wife who pointed him out to me, and she'd never met him, only seen photographs of him. But she knew it was him, she said, because of the way he

The landlord showed me the place: a basement apartment with no view, no windows, out of sight, invisible to the world. It was perfect. There wasn't much room, either, but that was okay. All I needed was

I'm not really sure who started it. We think we remember things exactly as they were, but our minds play tricks on us. I can close my eyes and convince myself that _____

I've got a theory about why kids are so fascinated by dinosaurs, boys especially. Boys like making messes, and nothing makes a bigger mess than a huge dinosaur stomping around and knocking down everything in its path. I can see that impulse in my own little boy, only three years old, when he

When the panic attacks came, she always found it helpful to imagine herself as a fish breathing through water. If a fish could find enough oxygen underwater, so could she. She identified with fish for other reasons, too—the way they

Someone wrote that insanity is doing the same thing over and over expecting a different result each time. By that definition, Harold was surely insane. Once again, he was

When did I start to lose you? If I knew where to find you, that's what I'd want to know. But no one will tell me where you are, and maybe no one really knows. I've asked your mother, and she says

Everyone agreed it was a brave thing to do, a real act of courage. Everyone also agreed that Mr. Mason was perhaps the last one you'd expect to do something like that. Until that day, we just thought of him as

Debbie sat by her window watching the storm, counting the seconds between the flash of the lightning and the crash of the thunder. The speed of sound was fast, the speed of light even faster. You couldn't see either of them, and that was why she loved physics, the science of the unseen. All of the important things in life were invisible,

There was no way I was going to admit anything. I had to protect myself. But I also had to protect

The trip should have taken us three days, but nothing went as planned. Nothing. I should have known it would all go wrong when Robert called and told me

He was seventeen years old and had never left the island. Although the air was cold and biting, he stood outside at the back of the boat, staring at the tiny strip of land until it became a speck on the horizon and disappeared altogether. Even then, he stayed there for a while, shivering and thinking

It was a long shot, but at the time it seemed worth it. What did I have to lose, anyway? I was divorced, and I hated my job. So when I saw the piece in the paper advertising

Maybe it was faith, maybe stubbornness, maybe something else. Maybe she didn't really know the risks. Either way, he had to admire the way she

His feet barely touched the ground as he ran. You couldn't take your eyes off him. That was on the football field. In the classroom it was a different story. There, he

When Lisa ran out of ice, I volunteered to go out and get some more. I needed the fresh air. I needed to think before I ended up doing something I regretted again. All I wanted was to

I wasn't going to let them fool me again. By this time, I'd had considerable practice at being fooled. You could almost say I was a professional. And they knew that. They knew about the time

I thought I knew her so well. She was quiet, dependable Millie, the woman I'd been married to for twenty years, who had raised three children with me, but now she

The sun would be up in less than an hour, but I couldn't afford to wait any longer. I got up and took a quick shower, moving quietly, trying not to wake the kids. When I got down to the kitchen, Nora was there making coffee. She asked me if anything was wrong. I hesitated before telling her that

"So you're saying it's possible?" I asked again, unwilling to give up. The two cops exchanged glances, as if they'd been through this many times before. The younger one put his hands in his pockets and looked down at his feet. The older one

I knew the day I met her I would ask her to marry me. And I guess I knew that she would say no, but I couldn't help myself when _____

We were behind schedule, but it was almost dark and time to set up camp. I told the men to get by on cold dinner of bread and cheese. Starting a fire was too risky, I said. It might

People talk about the calm before a storm. And that's what it felt like: there was electricity in the air, and it was invisible, and that made it even more powerful. A crowd had gathered outside City Hall and also at _____

was an accident, I told myself. And I kept on telling myself that, as if saying it over and over would make it true. But no matter what I told myself, it wouldn't change the fact that

He starts to talk, and it's like an old car struggling to start, the engine sputtering, not really sure it's up to the task. But then he gets going, the engine hums, and there's no stopping him. "Everyone said it was a crazy thing to invest in," he began, "but we knew

People pretty much hear what they want to hear, see what they want to see, believe what they want to believe. And I guess I fell into that trap as well. I wanted to believe

Our idea of an exciting date was to take the train into the city and spend the day going to museums together. We'd go for hours, barely saying a word to one another. Ted was someone you could be silent with, and when he spoke, it was because he really had something to say. He'd tell me

In his mind, he had run through so many different scenarios. He had tried to anticipate every possible turn of events. Yet life had, as it always would in the end, surprised him. It was his daughter Laura who

Count to ten, he told himself. Close your eyes, count to ten, and maybe it will be gone. He closed his eyes but just as quickly opened them again. It was real; it wasn't going away. Slowly, he raised the flashlight again and directed the beam toward

The universe is so big, the teacher was saying, we still see light from stars that died millions of years ago. Tommy sat up straight, flipped open his notebook and wrote: *Where does a star go when it dies?* His notebook was filled with

All right, you've told your story. That's how you remember it. But there's another story: my story. And my story begins with

Sometimes what seems like a blessing can actually be a curse, and the other way around. Rebecca had learned that the hard way, when

What are you supposed to think when your best friend tells you he's a vampire? At first, of course, I laughed, and thought it was a joke. But I wasn't laughing when Connor